*I made this vignette
because a ranch is so lovely.*

A Visit to the "North Forty"
Images from Atwood

Copyright 2016 by Echo Hill Arts Press, LLC.
All rights reserved, including the right to reproduce any part of this book.
ISBN: 13: 978-1523334704
ISBN: 10: 1523334703

Echo Hill Arts Press

A visit to the "North Forty"

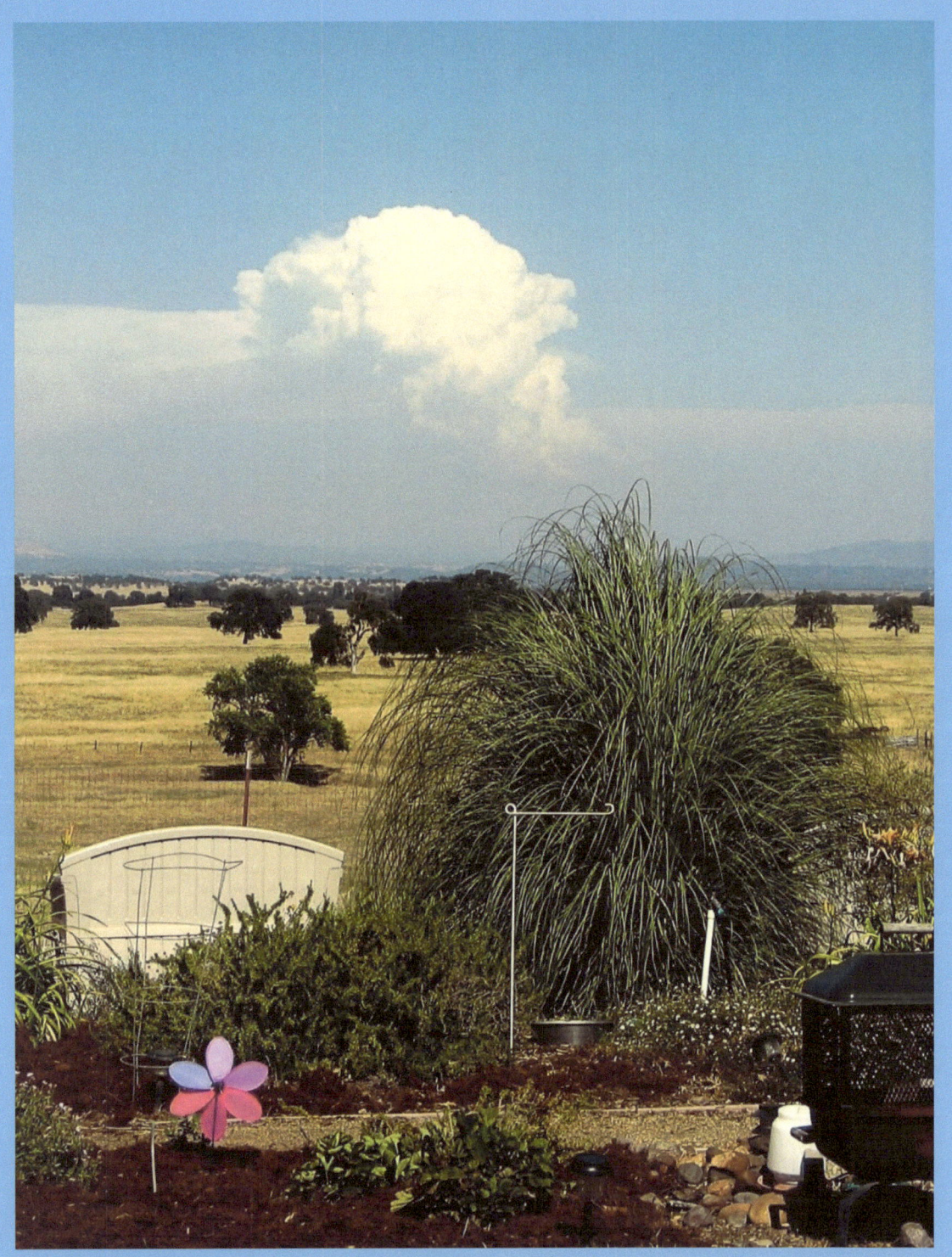

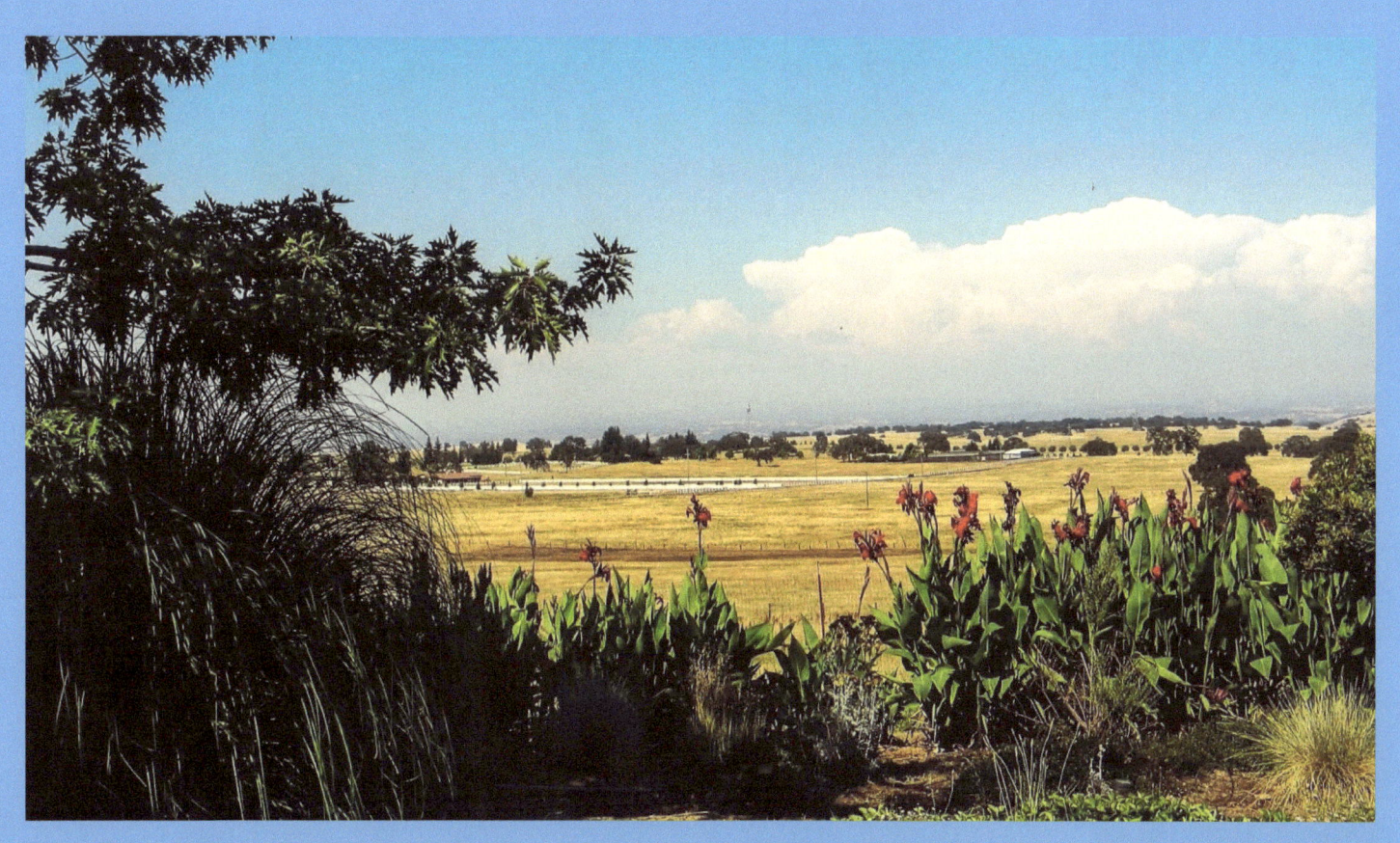

What a great spot! It's 100% central California.

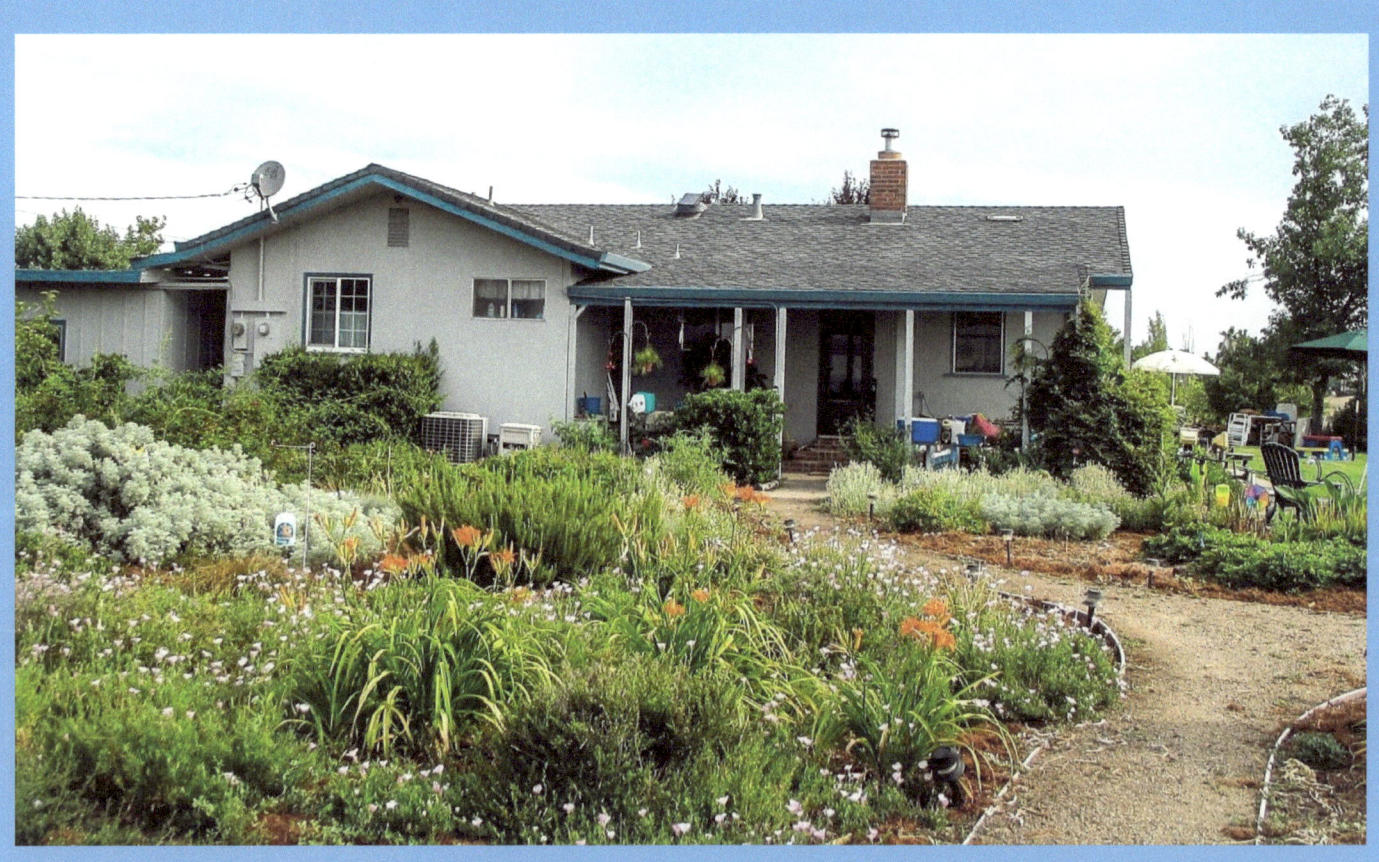

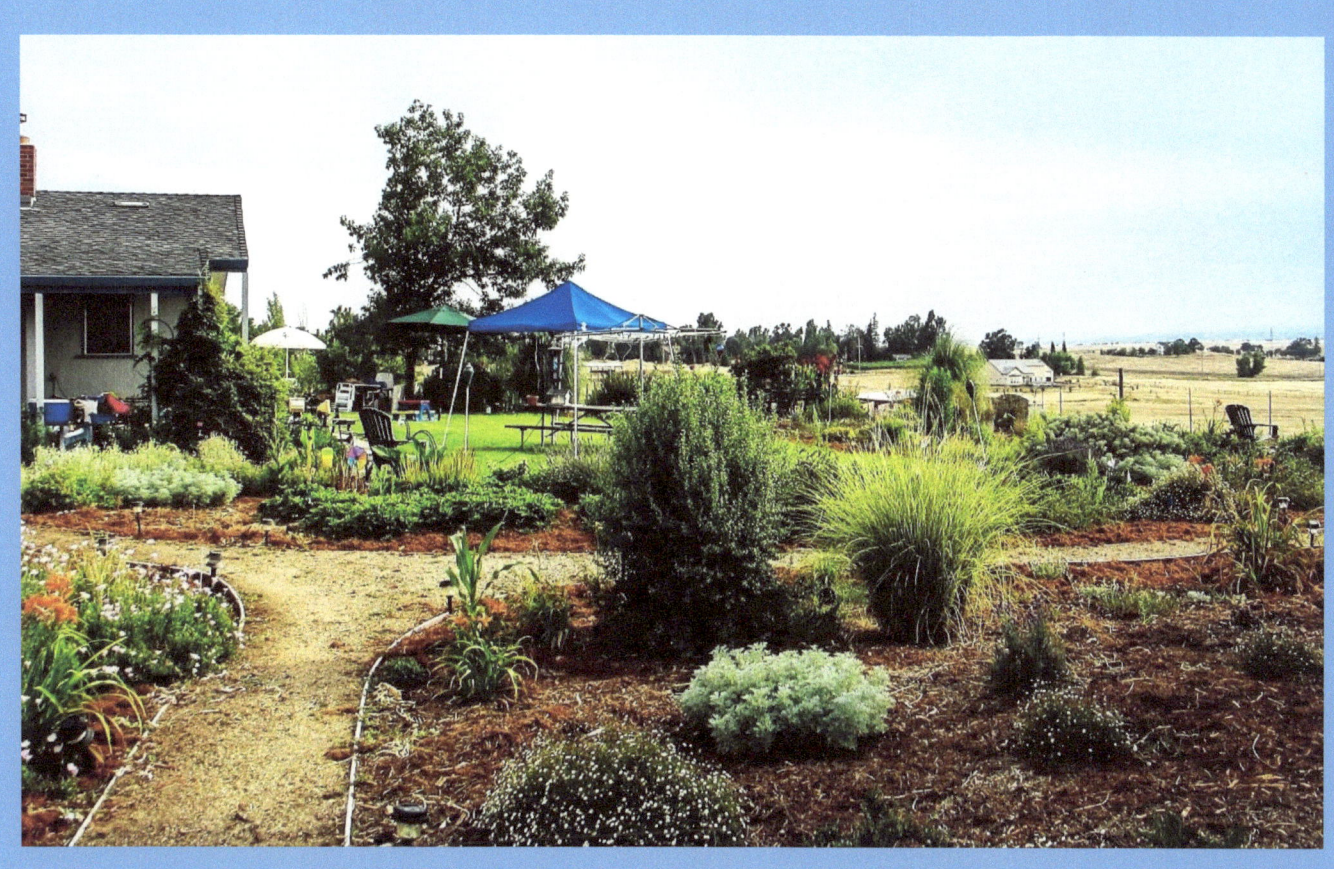

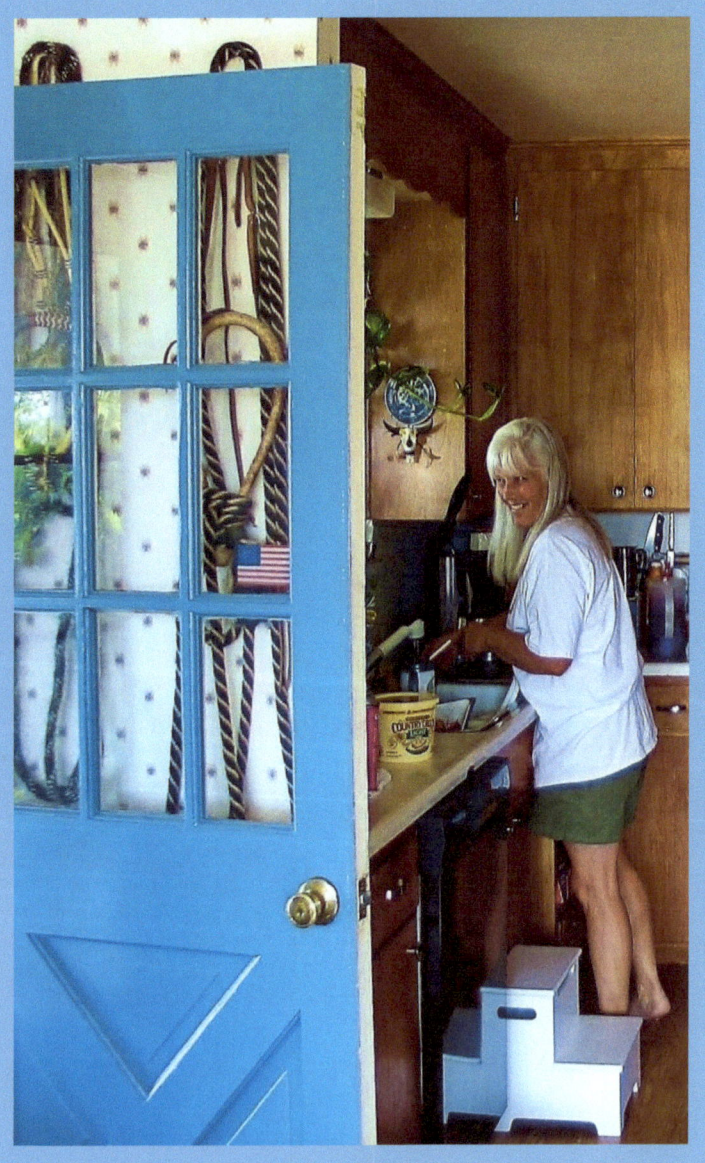

"Howdy. Welcome to the North Forty Ranch. Why don't you go out and look around while I finish up here?"

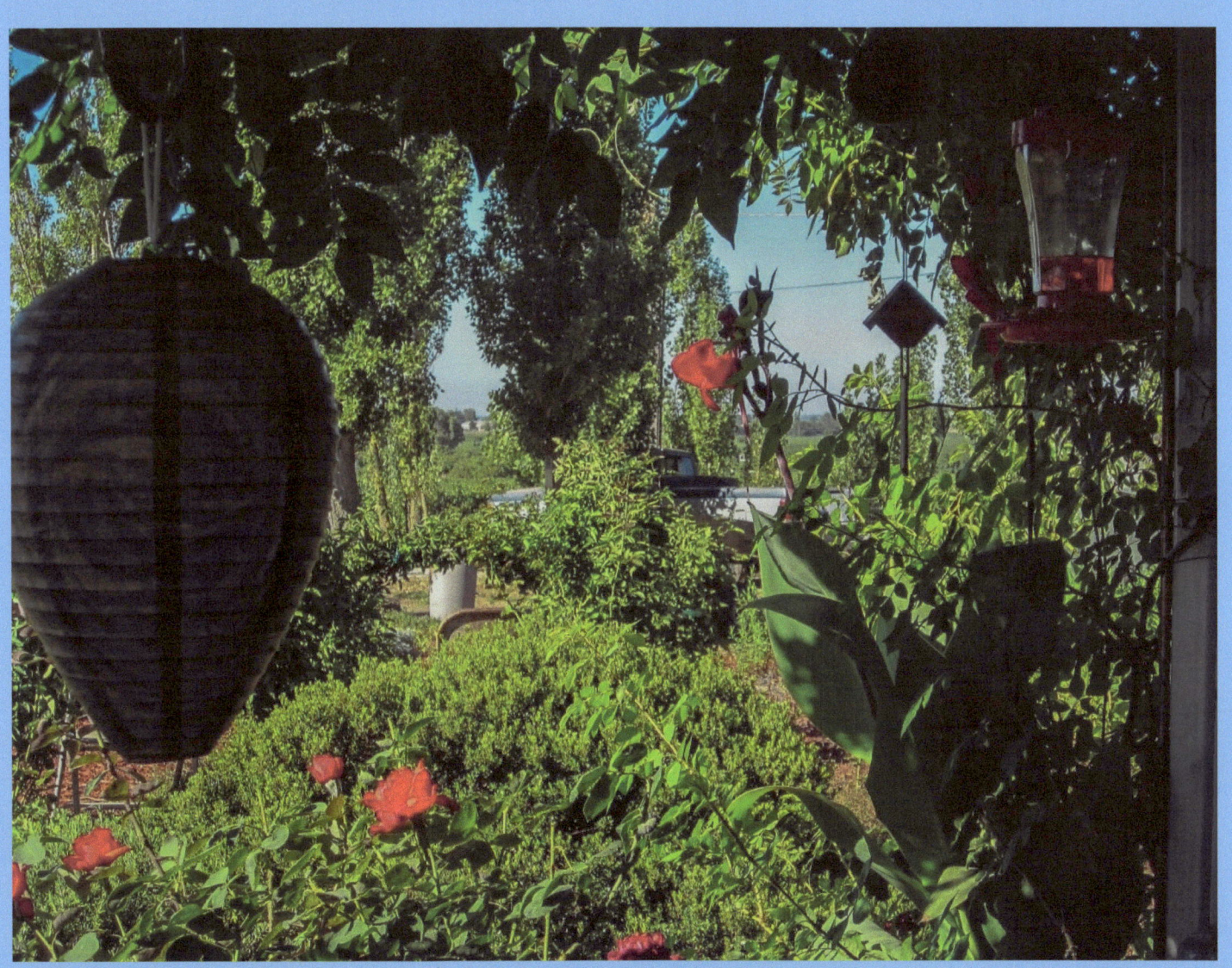

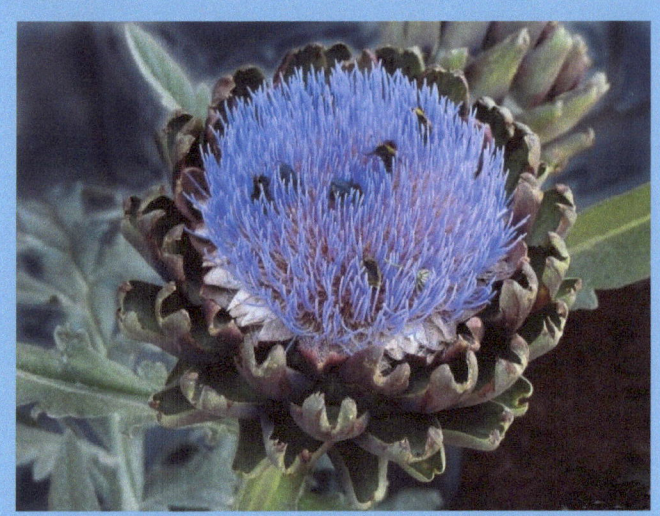

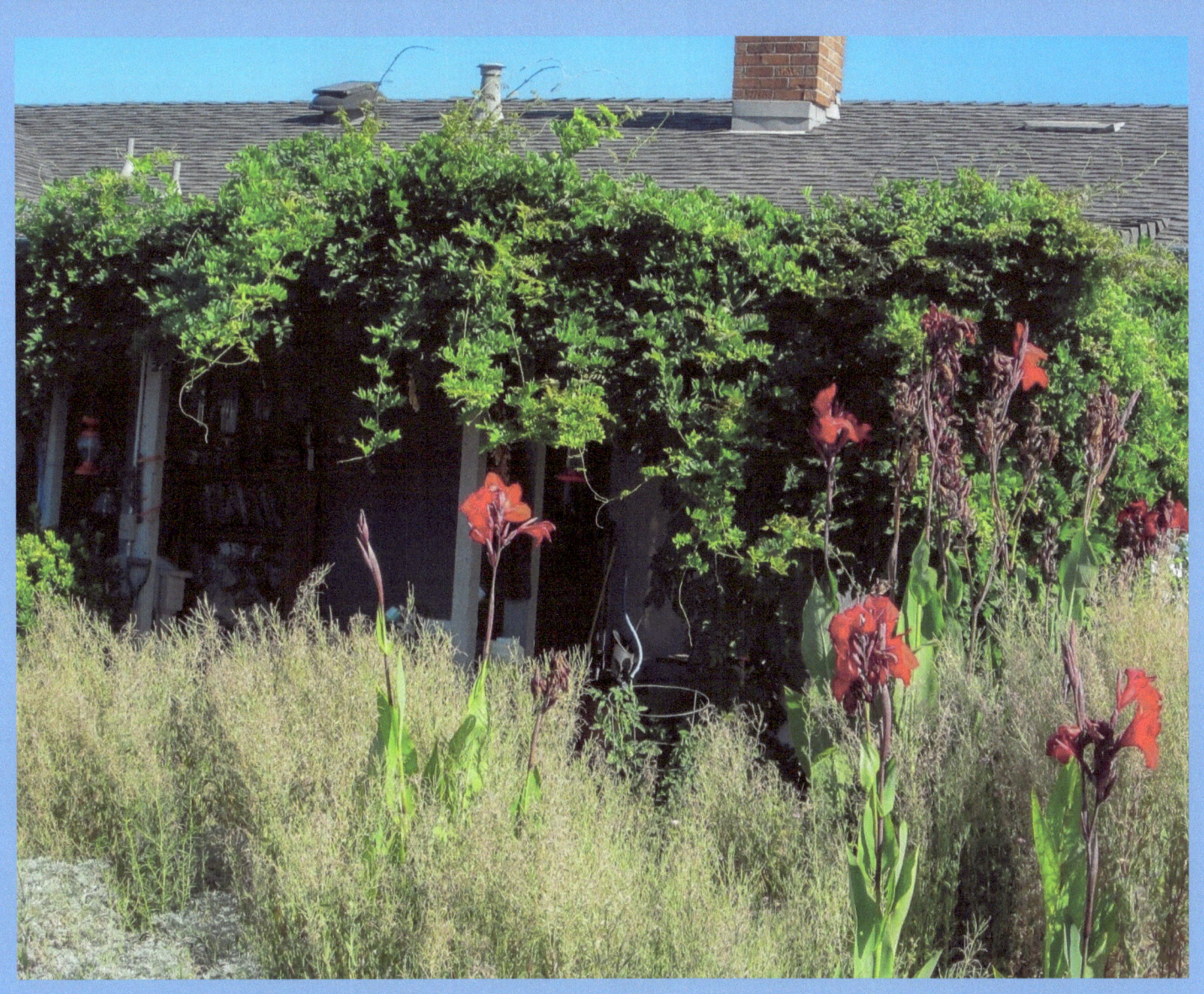

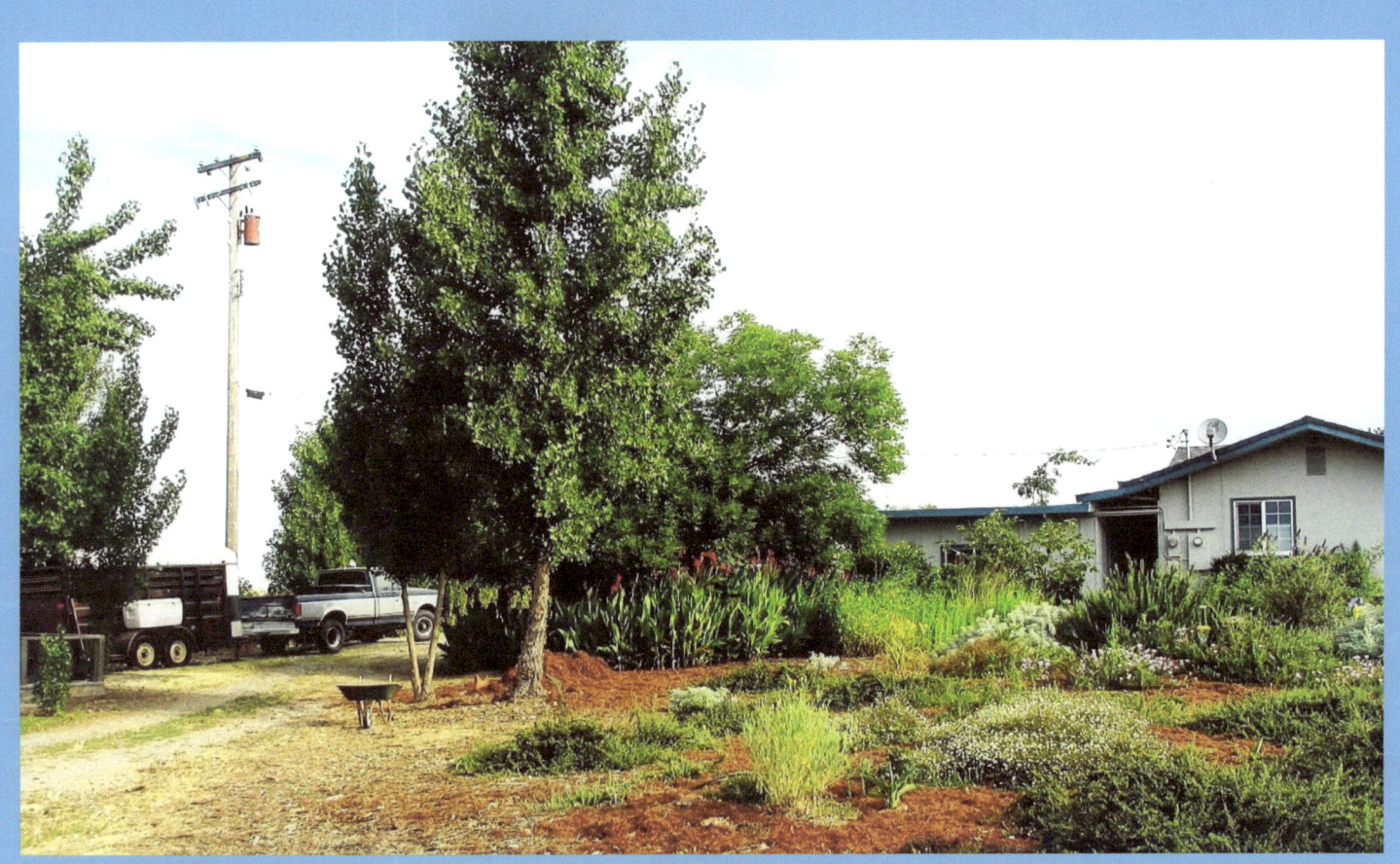

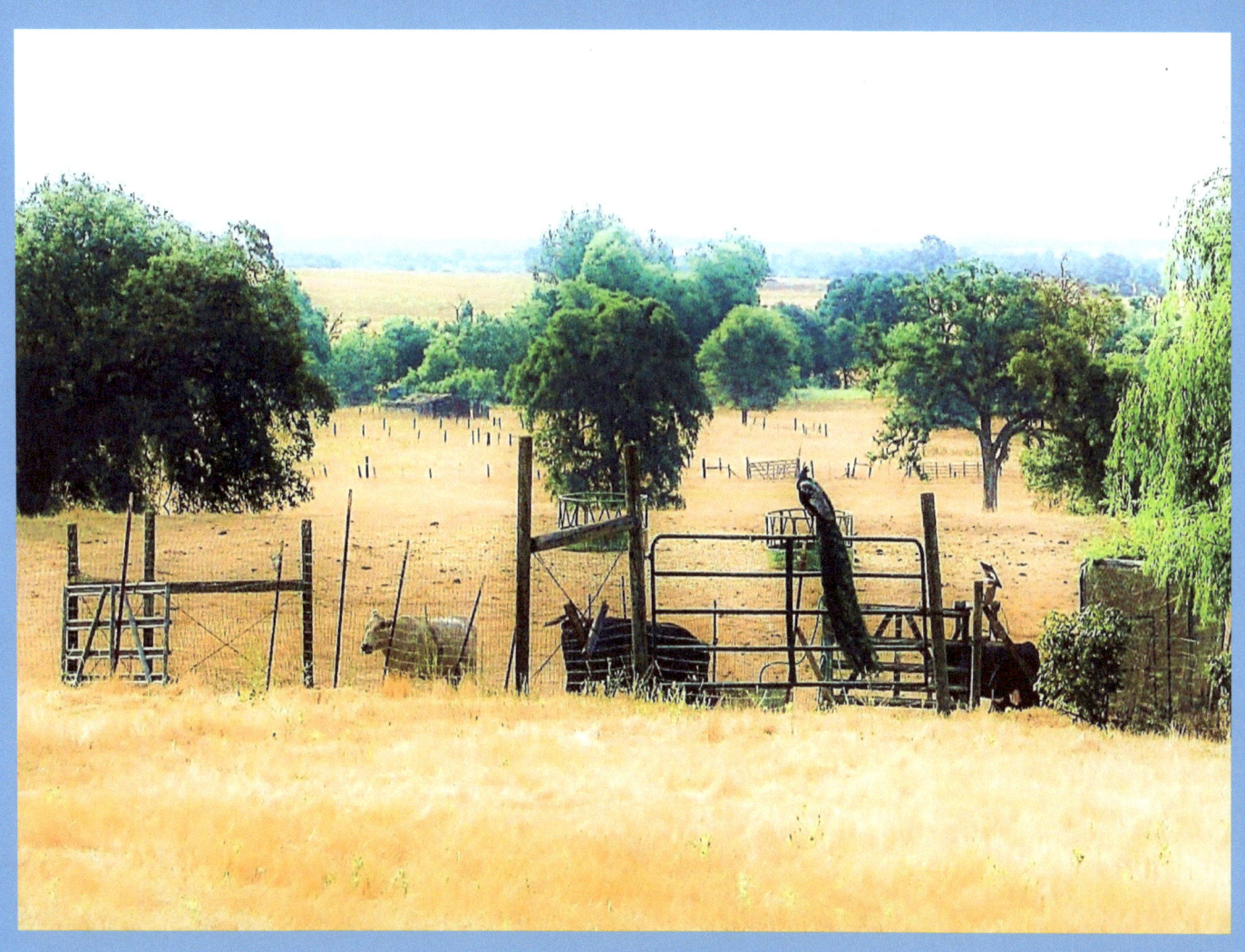

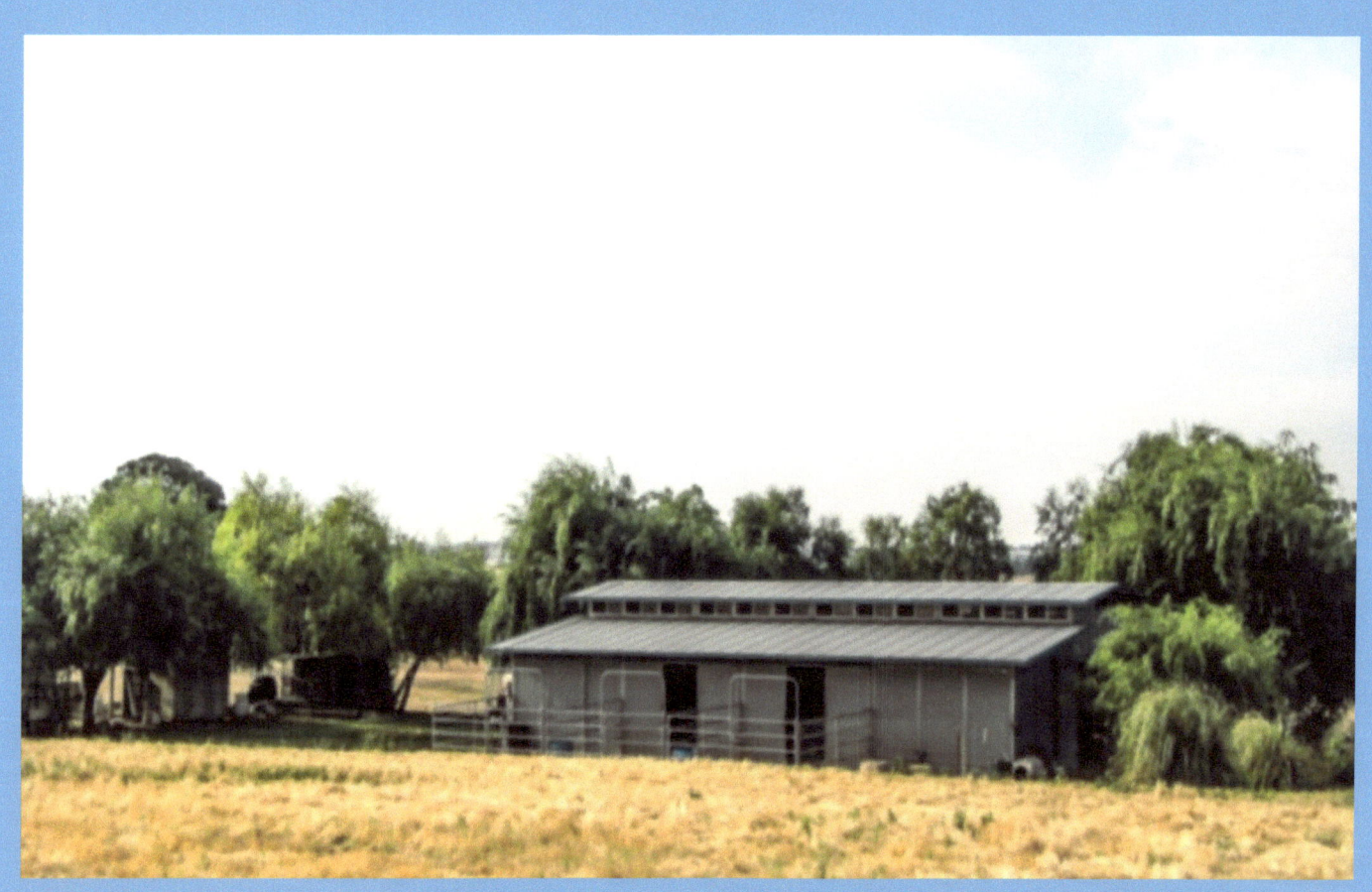

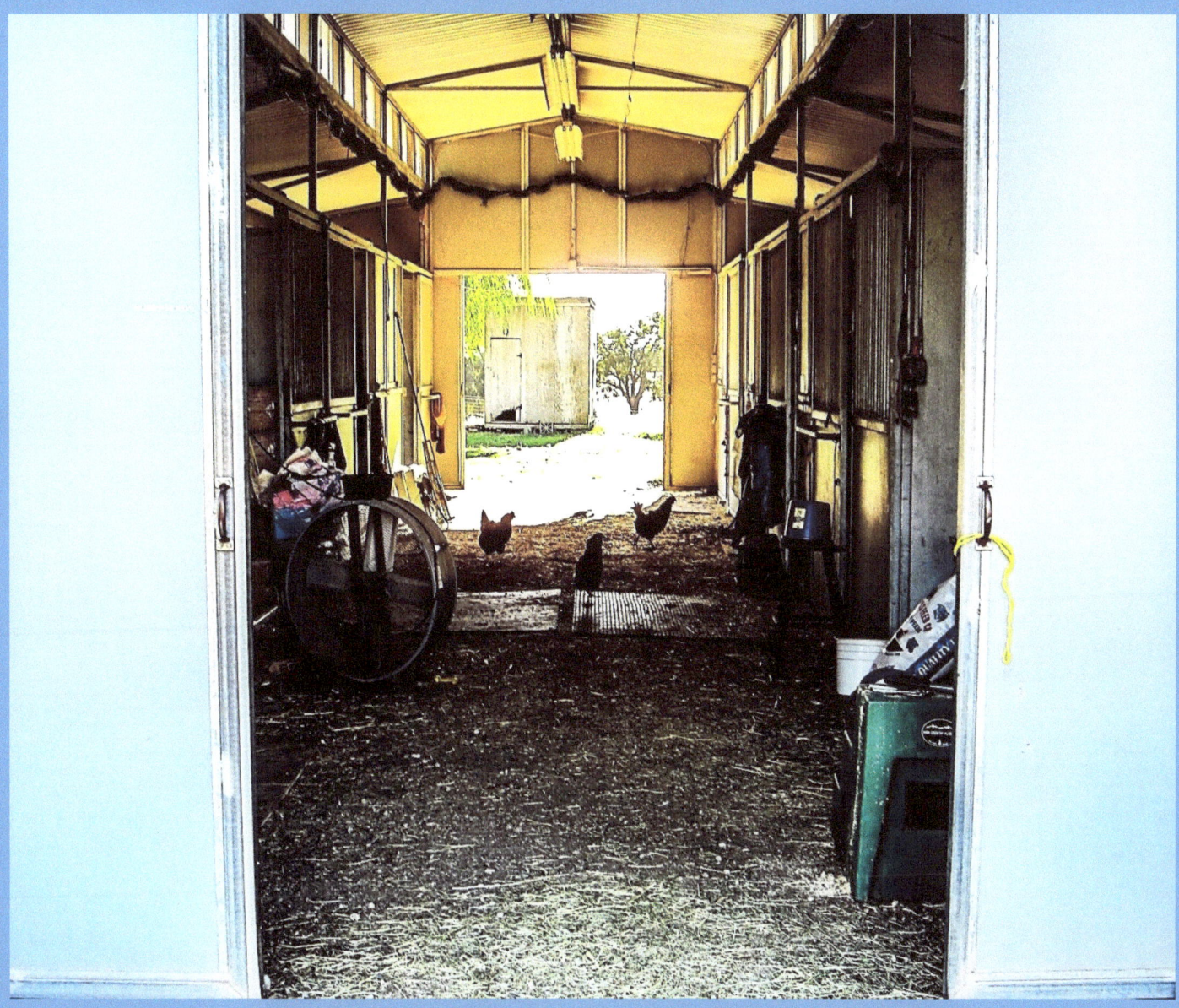

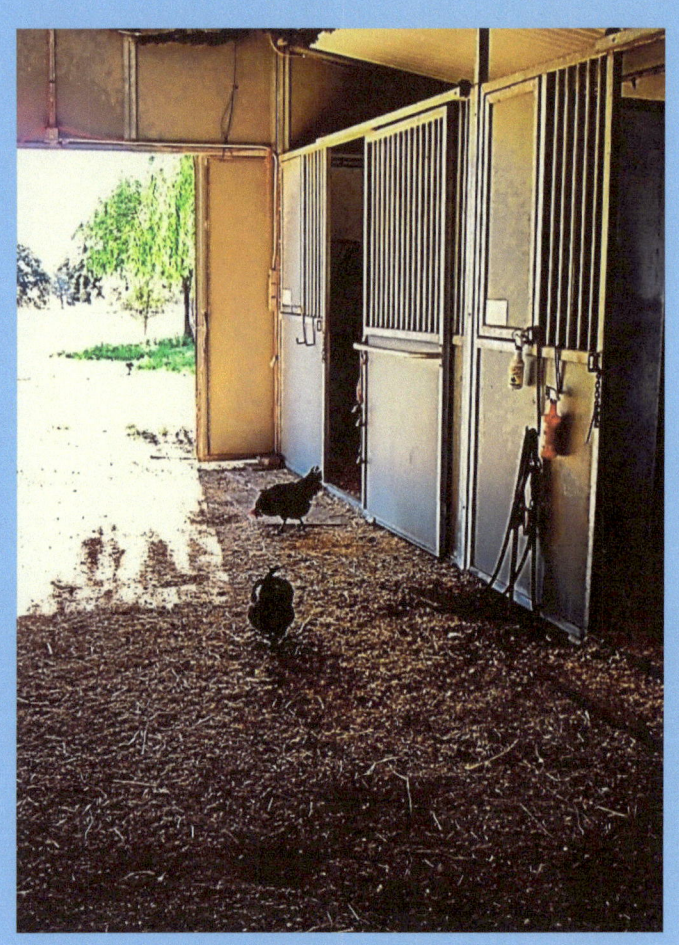
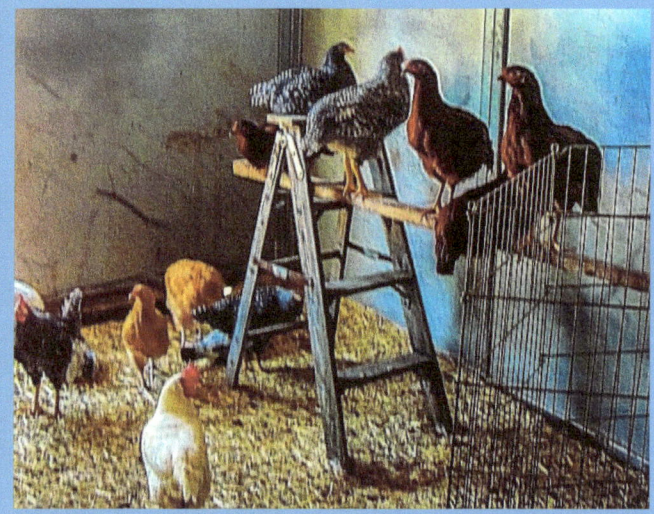

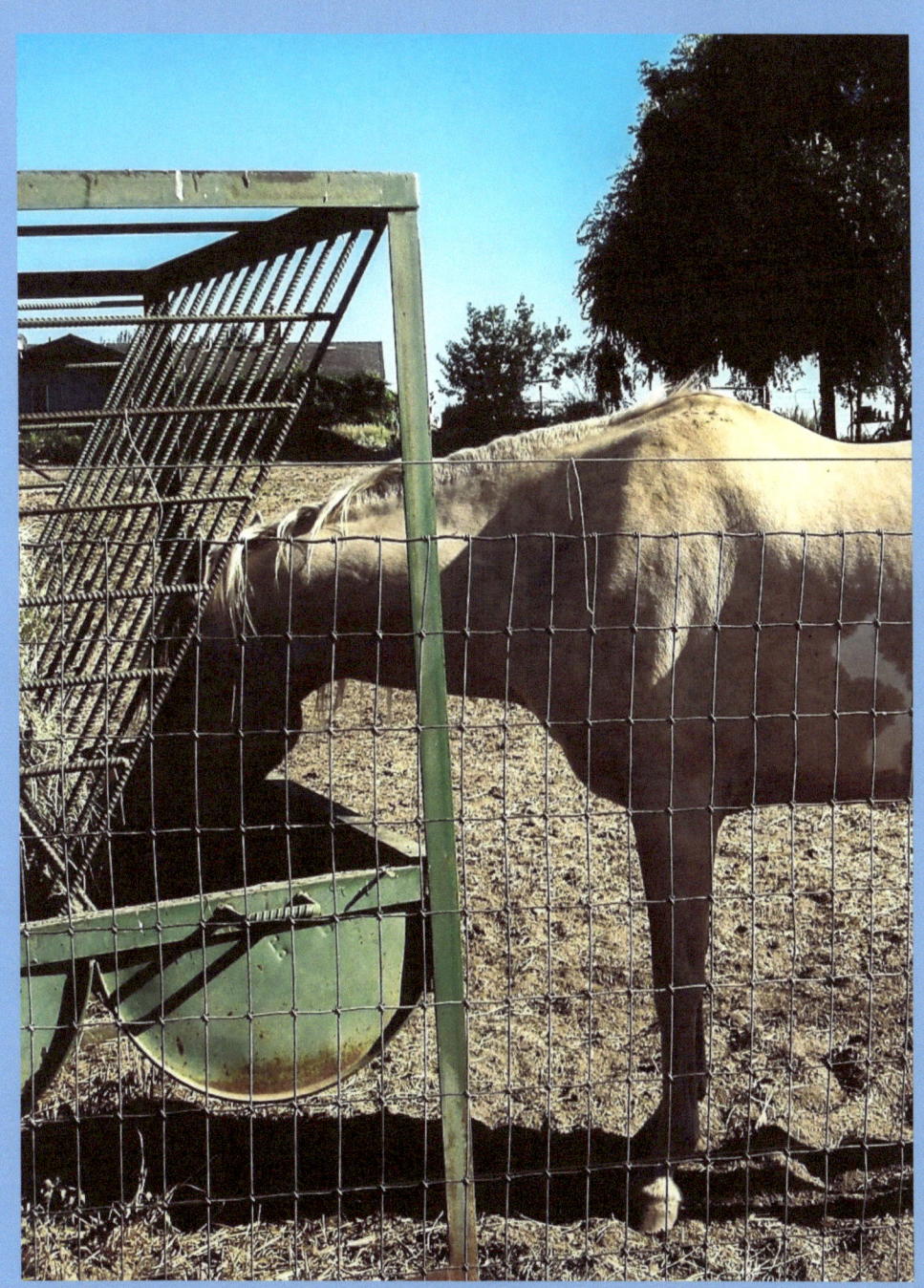

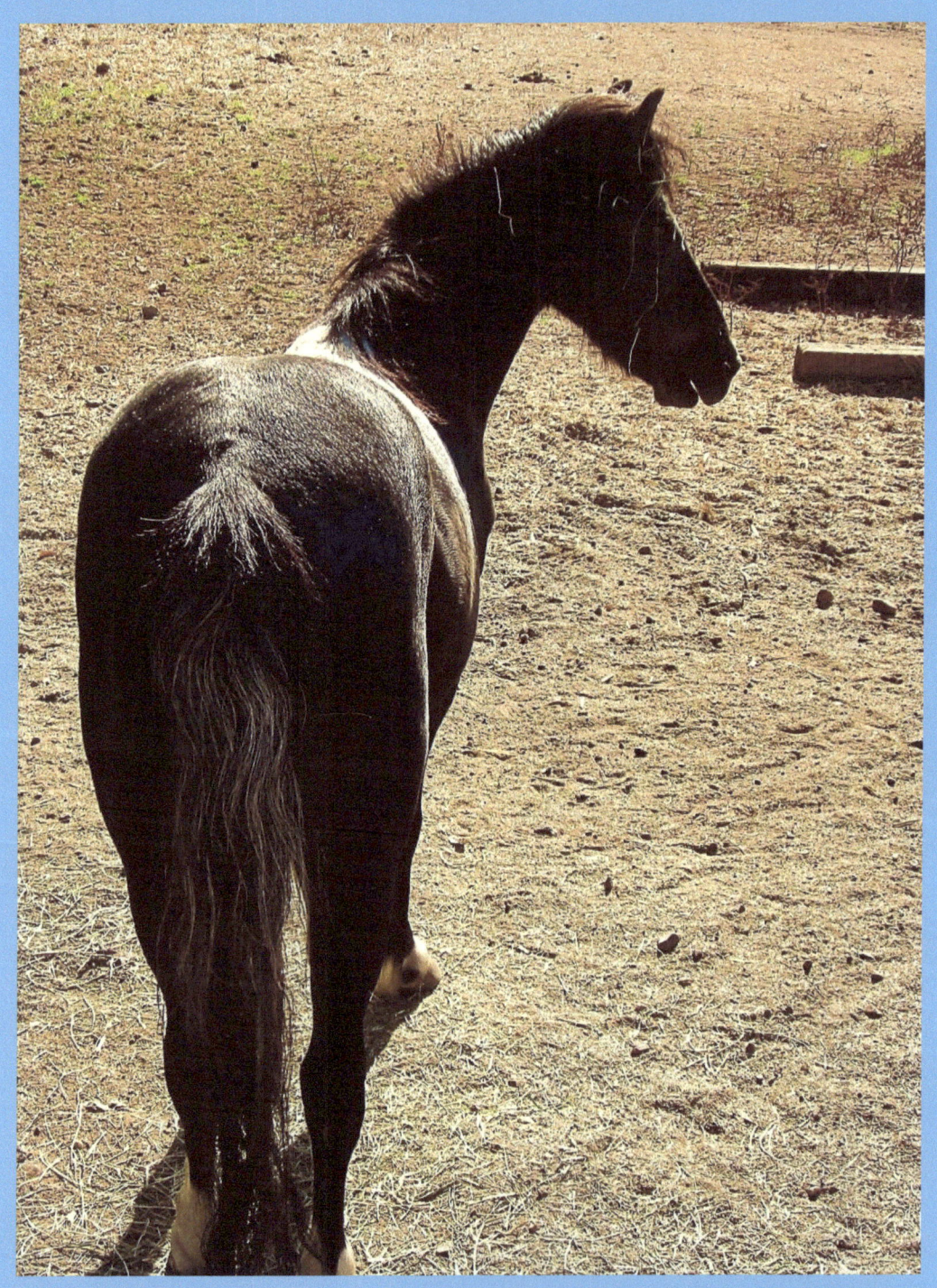

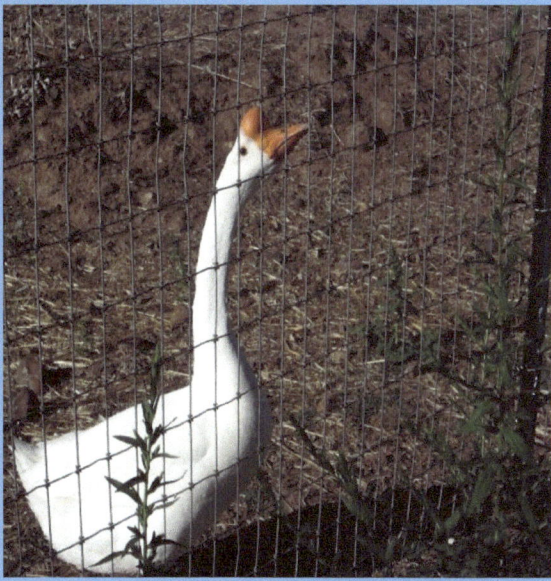

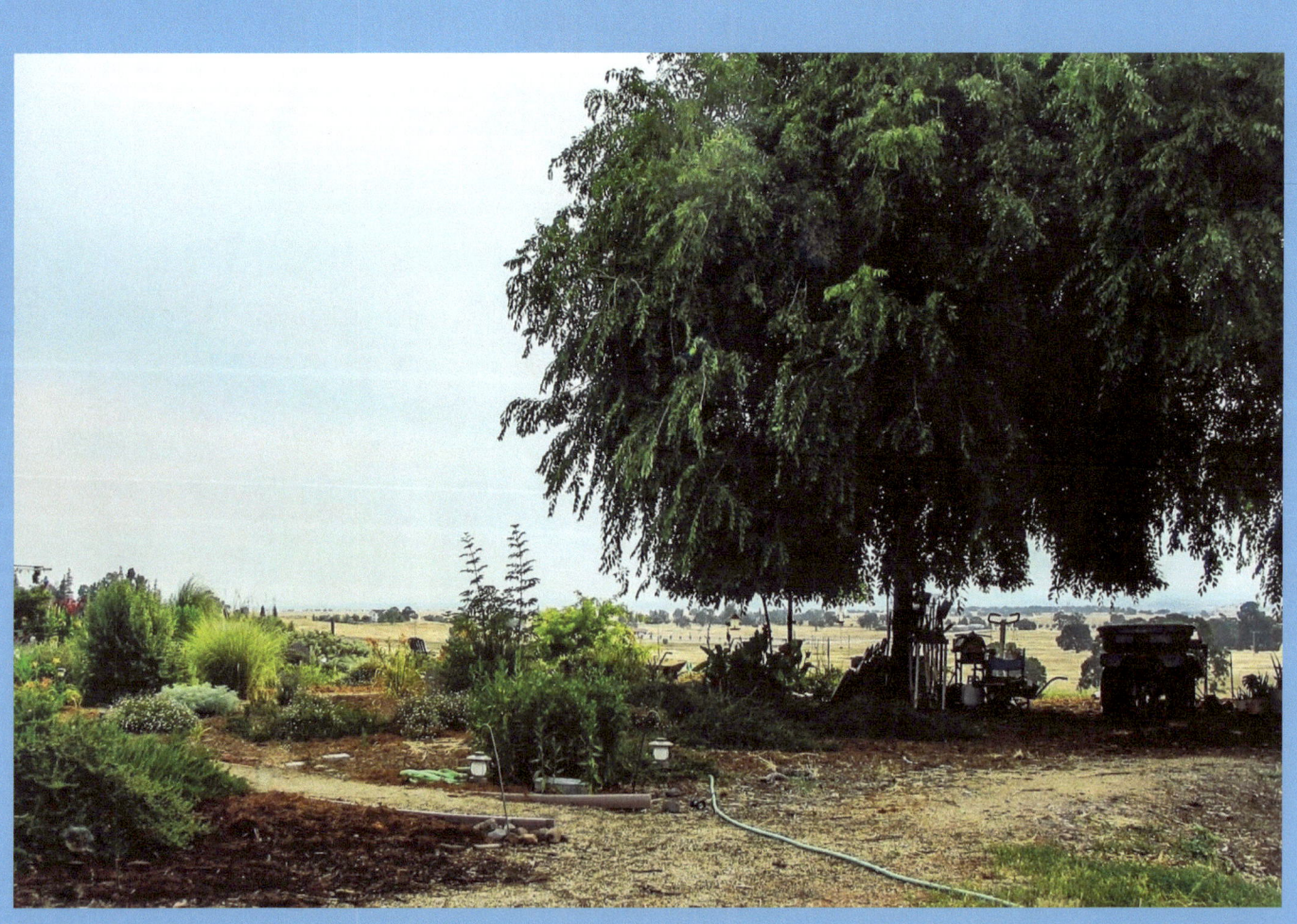

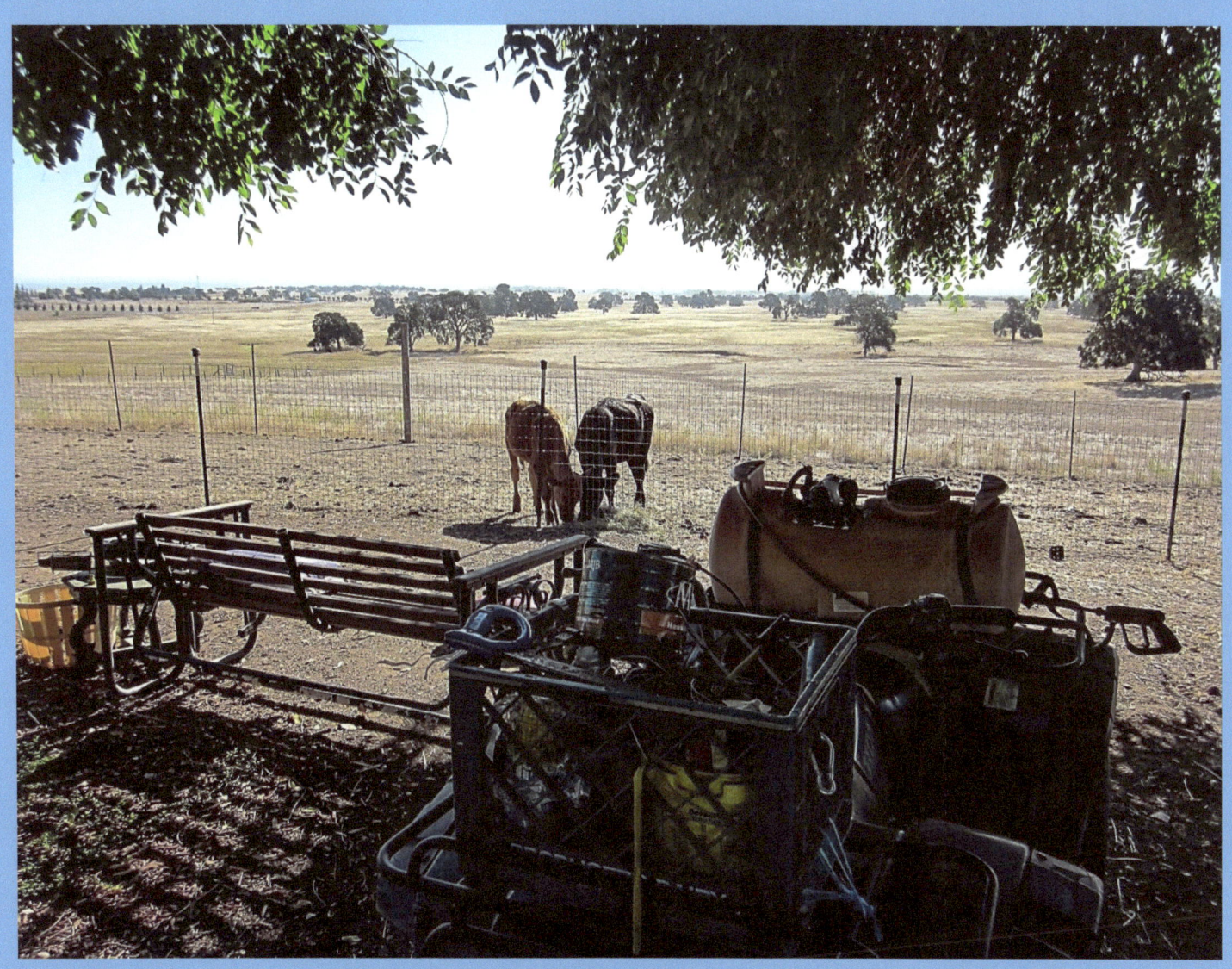

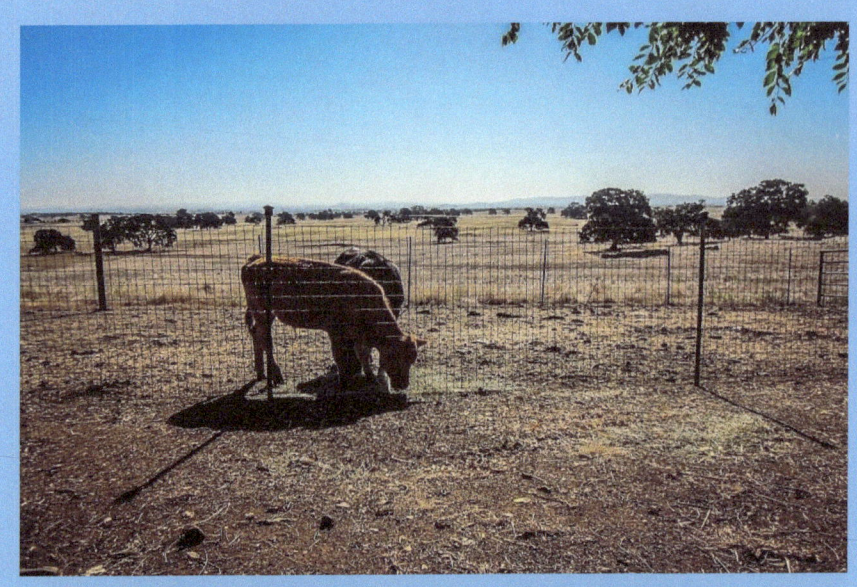
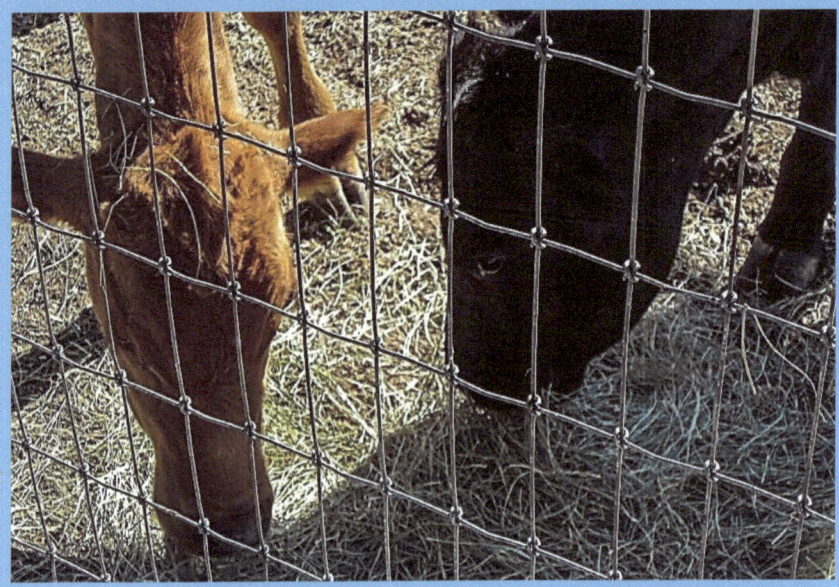

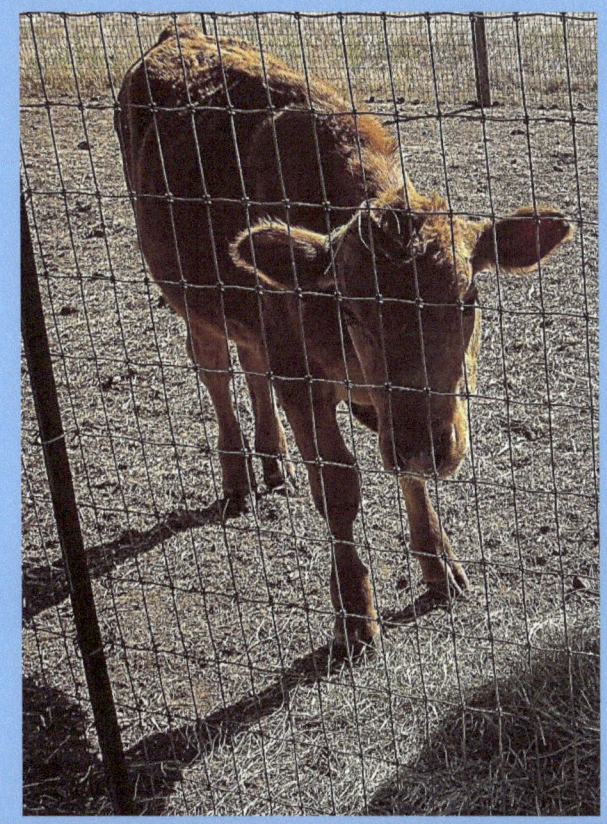

"I hope you'll enjoy your
stay at the ranch.
We're sure glad you came."

What's not to like?

*Every*thing is beautiful.

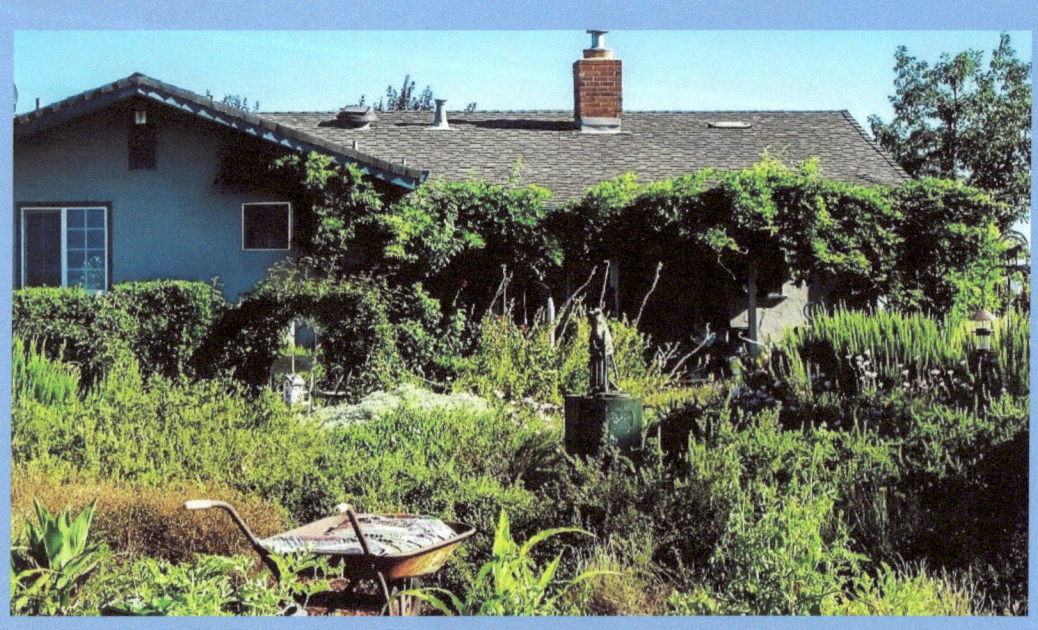

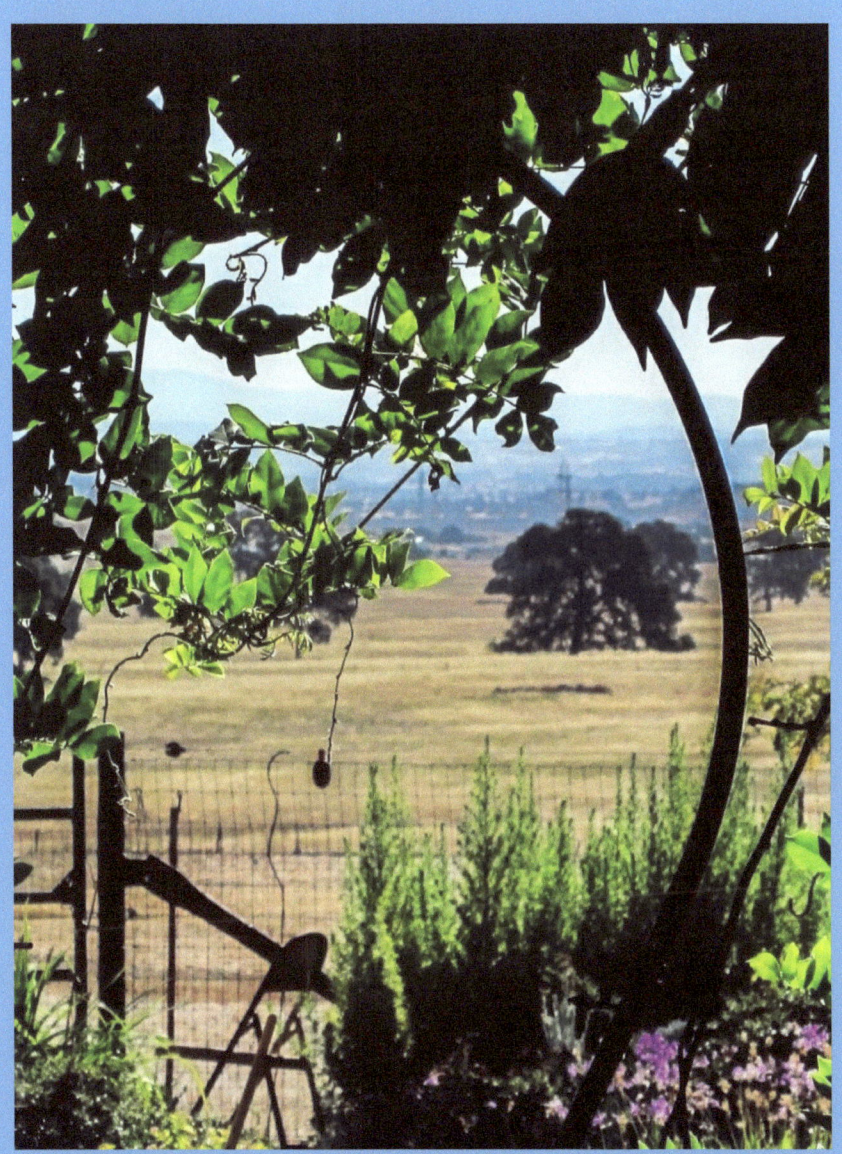

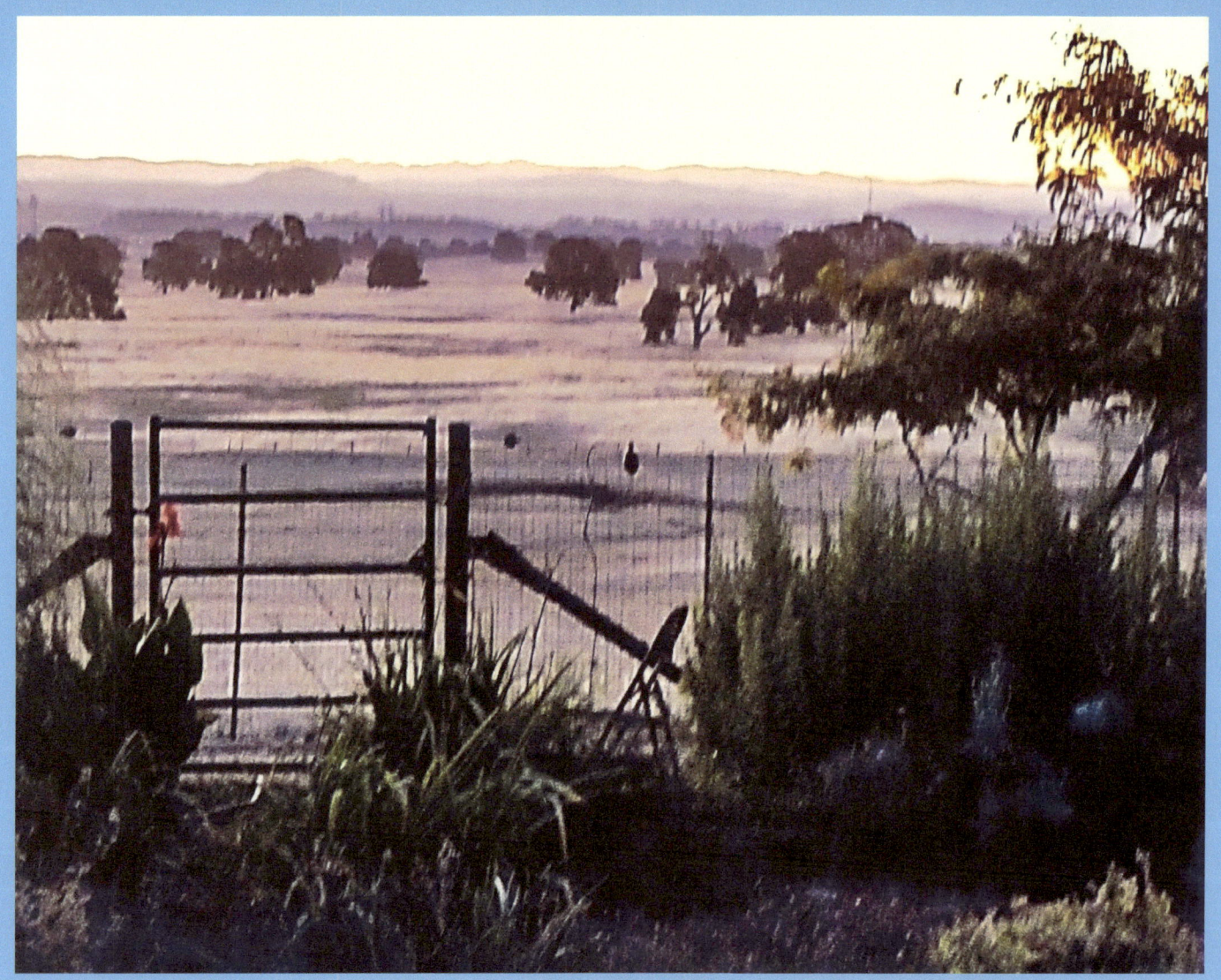

The view from this gate

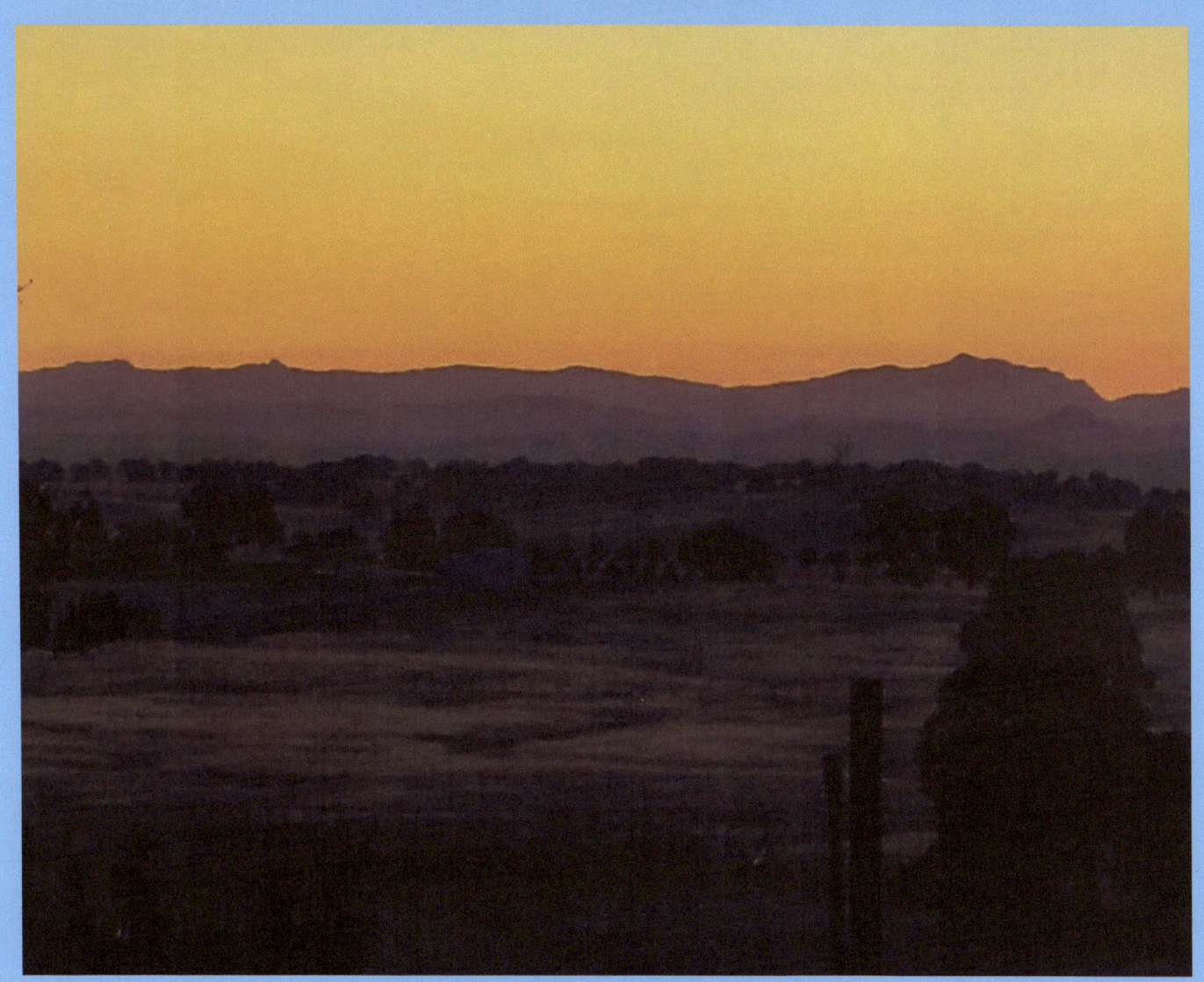

brings contentment to the soul.

Echo Hill Arts
is pleased to make a new line of
Images from Atwood
Photographic Diversions for Areas of Waiting

available Print on Demand
through **Amazon.com** and **CreateSpace Direct**

Echo Hill Arts Press

www.ingramcontent.com/pod-product-compliance
Lightning Source LLC
Chambersburg PA
CBHW041303180526

45172CB00003B/956